ALICE TRUMBULL MASON

ETCHINGS AND WOODCUTS

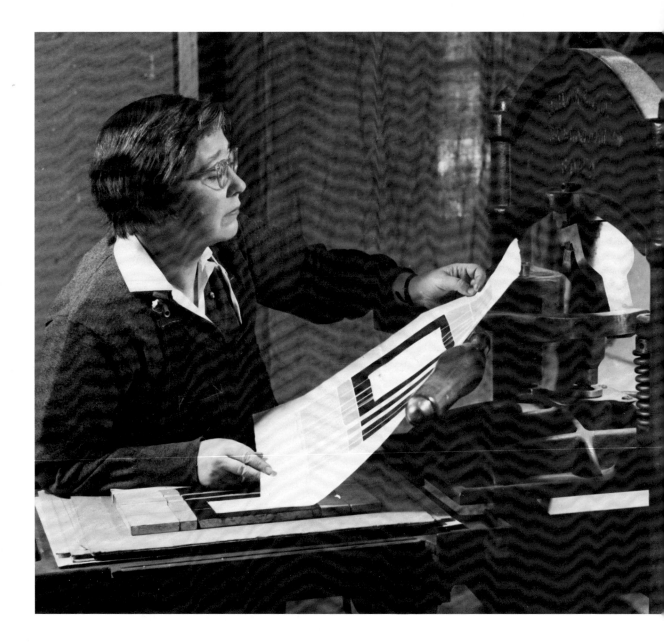

Alice Trumbull Mason

ETCHINGS AND WOODCUTS

with an introduction by Una E. Johnson

curator emeritus—Prints and Drawings

The Brooklyn Museum, New York

Taplinger Publishing Company

New York, New York

Frontispiece: Alice Trumbull Mason in her studio at
149 East 119th Street, New York City, 1954, by John D. Schiff.

Photographs of the art are by the following photographers:
Plate I, Geoffrey Clements; Plates II–XXI, Mark Ludak and Bob Wesler;
Plates XXII–XXV, Gamma One Conversions.

This book is made possible with the generous assistance of the
Martin S. Ackerman Foundation.

First edition
Published in the United States in 1985 by
Taplinger Publishing Co., Inc.
New York, New York

ISBN 0-8008-0160-1

ACKNOWLEDGMENTS

I wish to thank the following people for their help in putting this

book together: Joan Washburn, Jennifer Mitchell, Cecily Kahn,

Melany Kahn and Wolf Kahn.

I wish to thank the Ackerman Foundation for support in getting

this project started. EMILY MASON

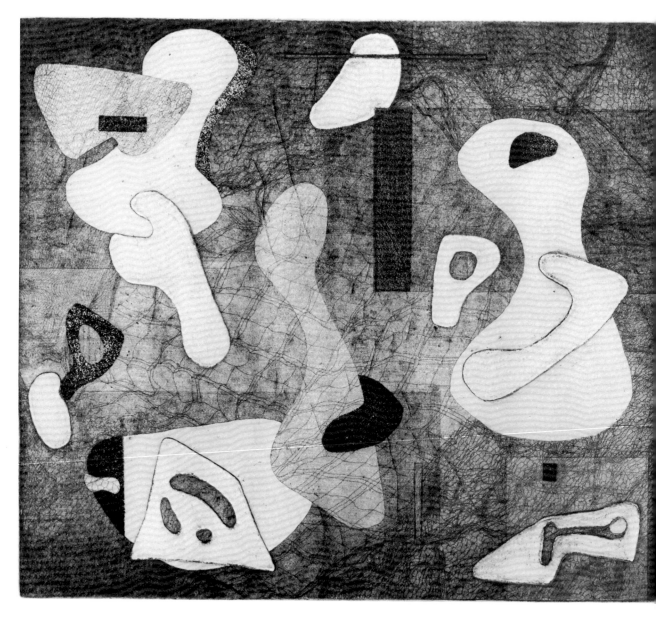

PLATE I INTERFERENCE OF CLOSED FORMS 1945

8/20 11.25 x 13 inches

ALICE TRUMBULL MASON IS ONE OF THE GIFTED AMERICAN ARTISTS, BORN WITHIN the first decade of the twentieth century, who early in her career pursued the ideas and images of abstract art. For this artist such a course was far removed from the large scale historical panoramas and portraits envisioned by John Trumbull, one of her forebears. Her growing understanding of abstract compositions also removed her from the themes of social realism practiced by many of her colleagues in the 1930s. The development of abstract images and the changing effects of color and color displacement were to become the leitmotif of her entire oeuvre.

During 1920–23 Alice Trumbull Mason, accompanied by members of her family, lived in Italy, spending much time in Florence and Rome. Several years later, in 1926, she embarked with an aunt on an extensive world tour. Late 1927 and 1928 found her studying the elements of academic art at the National Academy of Design and with Charles Hawthorne in New York City and Provincetown. This was followed by work with Archile Gorky who was teaching an unacademic course in painting at the Grand Central School of Art. She admired Gorky's eclectic point of view and his flamboyant enthusiasm for modern European artists and their evolving styles. Her earlier academic studies in drawing and painting formed a solid background for the new ideas and images.

In 1929 Alice Mason again returned to Italy extending her journey to Greece and the Greek Islands. Her early classical education and her knowledge of Greek and Latin made these new adventures richly rewarding. The cadences of the languages and the endless nuances of Greek and Italian art enlarged and intensified her devotion to painting. She was to recall many years later: "The big turning point came on that day when, after happily painting these realistic things, I said to myself, 'What do I really know?' I knew the shape of my canvas and the use of my colors and I was completely joyful not to be governed by representing things anymore." Semi-abstract landscapes soon gave way to entirely abstract compositions that she termed "architectural structures." Many experiments and refinements in form and color were to occupy her imagination and creative energy throughout her professional life.

Those American artists who first chose to work in an abstract idiom were given little or no recognition by critics, dealers or museums. Only the works of European artists were deemed worthy of attention. However, this opposition did not deter the artists who were exploring new images in their paintings and sculpture. To combat the vast lack of interest and even hostility thirty-nine artists met together to form an organization whose principal purpose was to present exhibitions of their abstract work and to hold regular discussions concerning their particular professional development. This group, formed late in 1936, was designated as the American Abstract Artists and was to play an innovative part in the development of the avant garde movement in the United States. Among its founding members were Burgoyne Diller, Gertrude Greene, Harry Holtzman, Paul Kelpe, Ibram Lassaw, Alice Trumbull Mason, George L. K. Morris, Ad Reinhardt, Louis Schanker, Albert Swinden, Vytlacil and others. Later they were joined by Piet Mondrian, Laszlo Moholy-Nagy and Josef Albers.

The first exhibition of the American Abstract Artists was held at the Squibb Gallery in New York in April, 1937. In order to promote their work this organization issued a portfolio recording drawings by thirty of the thirty-nine members. Printed in offset lithography, it was issued in an edition of approximately five hundred copies and was sold at the Gallery for fifty cents a copy. Somewhat to the surprise of the exhibiting artists—and much to the chagrin of disdainful academic artists and reluctant critics—the exhibition created considerable public interest. Needless to say, the portfolio itself has long since become a rare, early document in the history of American abstract art. The following year, in 1938, the American Abstract Artists held their exhibition at the Municipal Art Gallery. The informative essays in its catalogue were written by some of the exhibiting artists. It was, perhaps, the first recorded statement regarding the development of abstract art in the United States. The following excerpts are taken from Alice Trumbull Mason's essay that was written for this early 1938 catalogue.

"... The abstract painter builds his canvas without representation or perspective but in relation to the fullest use of the elements of paint that have appeared from time to time throughout the history of art.... For the abstract artist the field of painting is too great to be bound by any literary content and this is why he breaks with the past and looks into a new experimental world. Free from representational limits, he is able to explore more fully the potential factors within his medium: evidence of these factors has appeared at various times in every branch of art. They show clearly in the early Negro wood sculpture where quality, weight, texture and the peculiar characteristics of the wood determined the form and aroused the sculptor to new plastic and textural invention. And the pleasure the artist felt in working the wood is directly communicable. This is also true of the way the Archaic Greeks handled their media. At Ravenna there are heavy Byzantine mosaics whose relentless black lines sweep the processions of figures up the nave of the church to the huge mosaic Christ. The use of gold in the backgrounds is almost an abstraction of colour, being unrelated to nature and working well with the stylized lines of the figures. These and countless other achievements of the past are the things we build on and stem from; they are the indications of what may be done when an artist is fully aware and alive to the possibilities within his reach. Today we are free of the limitations these artists knew, we also have many new materials to work with; it is a period of vigorous experimentation.... We look for nothing mystical or dreamlike but the magic in the work itself. Abstract art demands an awareness of the intrinsic use of materials and a fuller employment of these means which build a new imaginative world by using them for their own potential worth."

For many years Alice Mason was an active member of the American Abstract Artists group and in 1951–52 served as its president. Her first one-person exhibition of paintings was held at the Museum of Living Art at New York University in 1942 under the perceptive sponsorship of A. E. Gallatin.

In the mid-1940s Alice Mason joined the American and European artists then working at Stanley William Hayter's Atelier 17 in New York where new possibilities and concepts were being opened up in the medium of the intaglio print. By this time her own visual vocabulary was established and she eagerly sought the new challenges of another medium. During the years 1945–46 Alice Mason issued nearly a dozen prints reflective of her early investigations and creative applications of the printed image. Among these works is an etching entitled *Interference of Closed Forms*, 1945, in which appear large white abstract forms set against a textured background and joined by strong black lines. This composition with some variations appears again in two prints: *Labyrinth of Closed Forms* and *Orientation of Closed Forms*. Her titles accent the developing visual elements and their changing emphasis. In her prints as well as in her paintings Alice Mason sought to convey an inner energy and tension which in turn create and sustain a particular mood or sensibility. On occasion in her prints the emphasis or thrust was varied by the changing order in which the plates were printed. *Inference of Closed Forms* received the Charles M. Lee print award in 1946 at the Philadelphia Print Club exhibition, although to one critic it appeared to be "an incomprehensible abstraction." Mason's *Labyrinth of Closed Forms* also was exhibited in this show. Seldom during these years did Alice Mason receive favorable or constructive reviews of her work. Today these particular prints as well as many others are ranked among the distinguished examples of twentieth century American abstract prints.

Early in her printmaking Alice Mason completed *White Scaffolding*, 1946, an etching and aquatint whose strong linear sections dominate a background of finely woven meshes and veiled abstract forms. *Suspension*, 1946, a soft ground etching with two colors, carried forward her pre-

sentation of interwoven images. Color in its countless intensities and gradations appear in much of the artist's graphic oeuvre. It is subtly present in *Surface Tension,* a four-color intaglio issued in 1946 and in *Inverse,* an etching and aquatint with one color completed during the same period. In her preoccupation with color the artist was later to recall: "There is an etching called *Indicative Displacement,* 1947. Displacement is what I see happening when colors are placed beside one another. I intend displacement and not the appearance of color lying in back or in front of another [colour]. This is my intention because I am convinced that twentieth century art should no longer imitate nature." She further explained: "An abstract artist may choose to hold up a tragic and expressive mirror to our time—building and not destroying. It is making color, tonality, dark and light, rhythm and balance work together without depending on references and associations."

In 1949 Alice Mason installed an etching press in her own studio so that she would no longer need to go to a professional printing workshop. This press was loaned to her by the printmaker Letterio Calapai for an indefinite period, and this fortunate circumstance allowed her to work with greater concentration and with fewer interruptions. Also at this time she issued a few prints in stencil and in woodcut methods that afforded her a more dramatic and direct use of color. Nevertheless she continued to work in intaglio, as seen in the soft ground etching entitled *Meanderthal Roturns,* 1947, a title taken from her readings of James Joyce's *Finnegan's Wake.* Mason's titles are often provocative and ambiguous rather than descriptive. She enjoyed these qualities in the elaboration of language in *Finnegan's Wake* where words and phrases were often shattered and rearranged. The artist's striving for the essence of a mood and its visual interpretation gave her a special appreciation of Gertrude Stein's opera libretto *Four Saints in Three Acts* and its seemingly wayward absurdities, and strengthened to a personal correspondence between artist and author. Alice Mason also was cognizant of the stark forms seen in the modern dance and in the complicated rhythms of contemporary music.

The exuberance and vitality noted in the middle decades of twentieth century American abstract art was reflected in its growing assurance. The strong visual sensibilities of Piet Mondrian, Ad Reinhardt and a few other artists held a fascination for Alice Mason. In 1947 at Carl Holty's studio, Joan Miro and his assistants were at work on Miro's large mural (now located in the Cincinnati Art Museum) that had been commissioned by the new Terrace Plaza Hotel in Cincinnati, Ohio. Alice Mason greatly admired Miro's paintings and their lively abstract forms. She recalled that she and Holty had shared a telephone that was installed in a small opening in the thick wall that separated their two studios. Thus Alice Mason had occasion to observe the progress of the mural from this unobtrusive vantage point. In its last stage the mural was slightly delayed because of the elusiveness of a particular color. Mason remembered when the color was finally properly mixed that Miro had taken the magic can of paint and applied it with a small long-handled brush as he "literally danced along the full length of the canvas." For Alice Mason the "rightness" of a work of art and the professionalism of its final execution were of utmost importance—a goal worthy of a lifetime of endeavor.

The artist often turned to the woodcut and stencil methods. These particular graphic techniques generally require simplified forms and more direct imagery. *The White Current*, a woodcut issued in 1952, is composed of three large interlocking forms that stand without any textured background. *Tidal Depths Sekishu*, also a woodcut, and *Starry Firmament*, an etching, both issued in 1954, are compositions that accent Alice Mason's continuing visual preoccupation with varying interpretations of the rectangle and the square. These bold forms are carefully contained within a grid of differing densities and placed against a background of shifting patterns of undefined space. At a time when large-scale prints were first much in evidence in the late 1940s and 50s, Alice Mason chose a less aggressive format for her prints and paintings but one whose visual impact rivalled those of larger dimensions. A combination of geometric and amorphous forms is noted in the woodcuts in colors—*Laughter*, 1955, and *Wind and*

Water, 1959—where muted and enriched colors produce a heightened sense of mystery. The artist's overriding intention was to capture the very essence of an idea and to place the visual image of that idea within a fully orchestrated composition.

Alice Trumbull Mason participated in numerous group exhibitions of paintings and prints during the decade of the 1950s and 60s. She died in 1971. In 1973 she was given a retrospective exhibition of her paintings at the Whitney Museum of American Art. One of her later prints is entitled *Cool Arch,* a woodcut in color of 1960, printed on black mat paper in an edition of twenty-five impressions. This was followed by *White Juncture,* 1964. Among her final graphic works is *Ionic Series,* a woodcut of 1968. A splendid geometric abstraction, it is one of the artist's larger graphic compositions and follows closely the purely abstract concepts seen in her three drawings entitled *Series in Sequence.* In its restrictive forms, well-conceived balances and strong but minimal colors, *Ionic Series* is a finely tuned realization of her long-held vision of "architectural structures."

Una E. Johnson

Now of course it is perfectly true that a more or less first rate work of art is beautiful but the trouble is that when that first rate work of art becomes a classic because it is accepted the only thing that is important from then on to the majority of the acceptors the enormous majority, the most intelligent majority of the acceptors is that it is so wonderfully beautiful. Of course it is wonderfully beautiful, only when it is still a thing irritating annoying stimulating then all quality of beauty is denied to it.

GERTRUDE STEIN

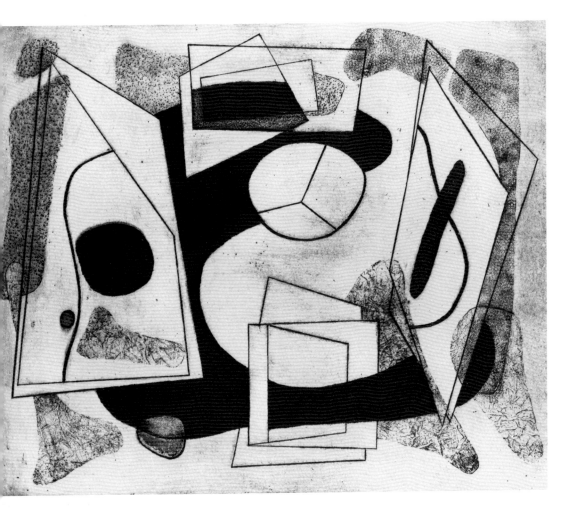

PLATE II AQUA BLACK 1945

1/10 8.5 x 10.375 inches

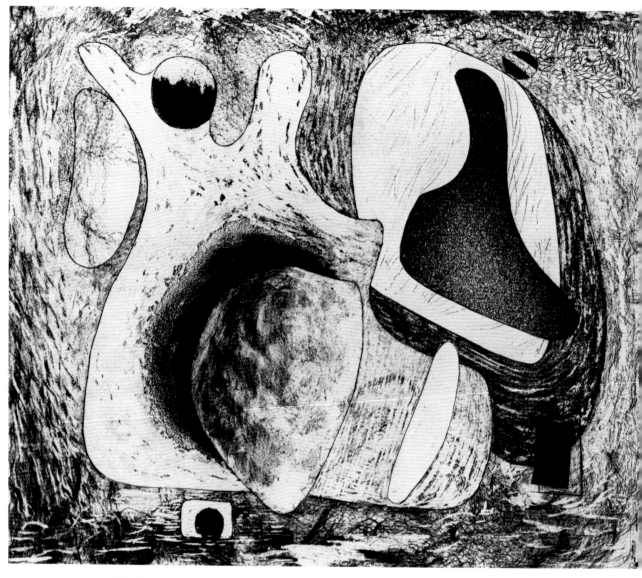

PLATE III PASSAGE TENSION 1945

s/p 12.25 x 14.5 inches

16

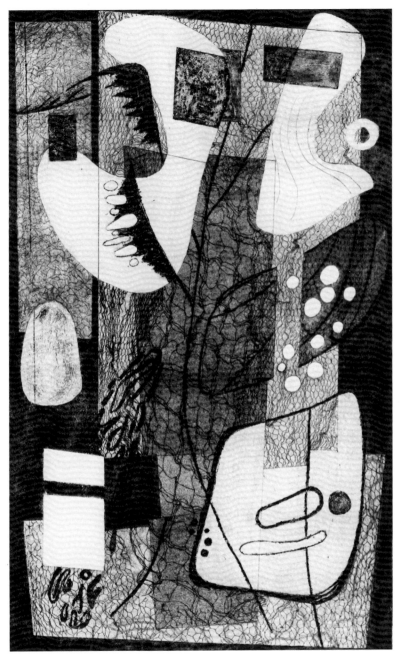

PLATE IV ORIENTATION OF CLOSED FORMS 1945

13/20 15.75 x 9.75 inches

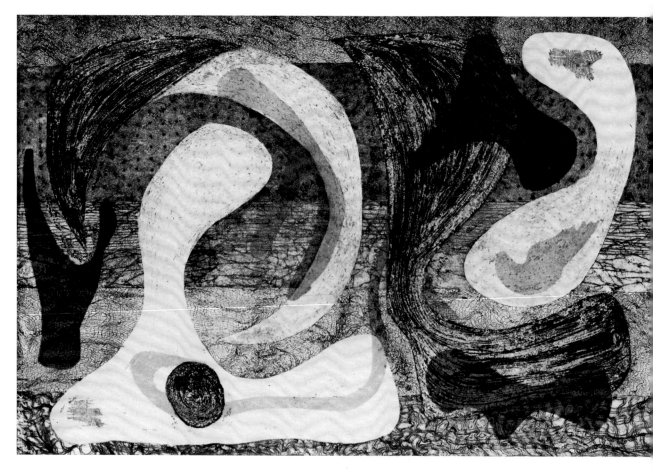

PLATE V SUSPENSION 1946
 9/30 9.875 x 14.625 inches

18

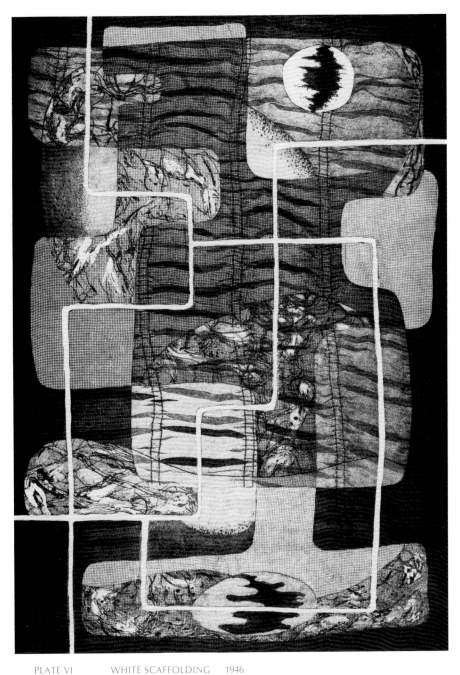

PLATE VI WHITE SCAFFOLDING 1946

8/30 13.5 x 9.625 inches

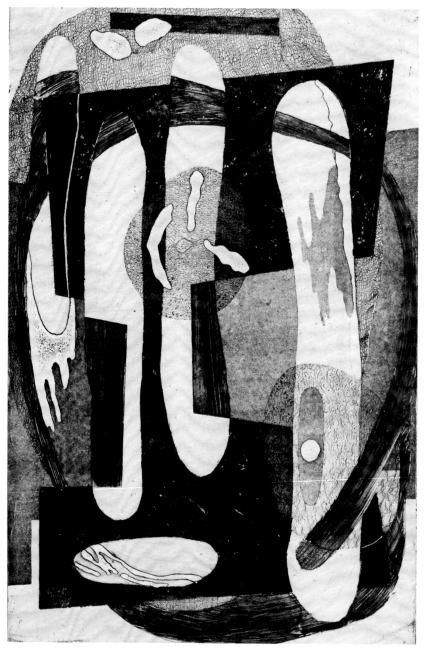

PLATE VII DOUBLE IDIOM 1946

24/25 14.75 x 9.75 inches

20

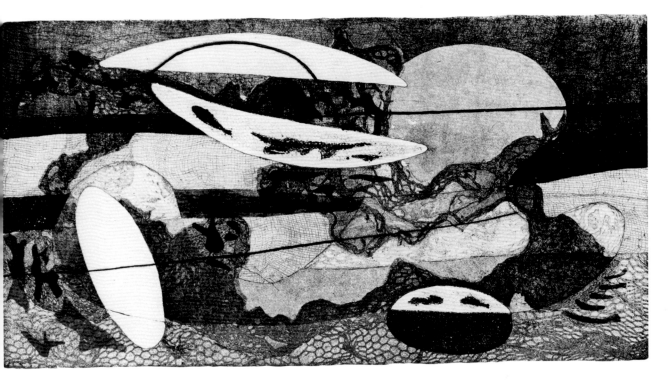

PLATE VIII WHITE BURDEN 1946

9/30 8.125 x 15.75 inches

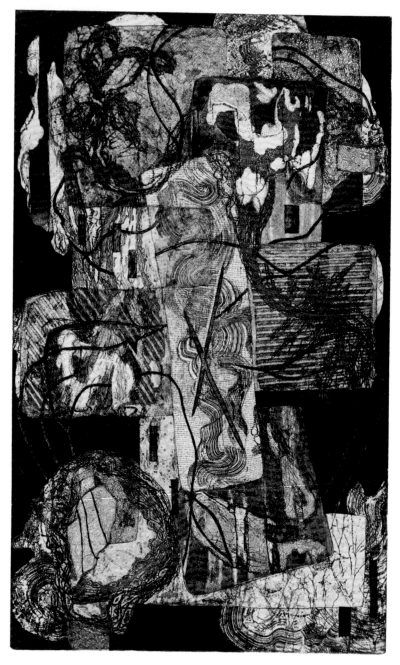

PLATE IX MEANDERTHAL ROTURNS 1947

8/25 15.75 x 9.625 inches

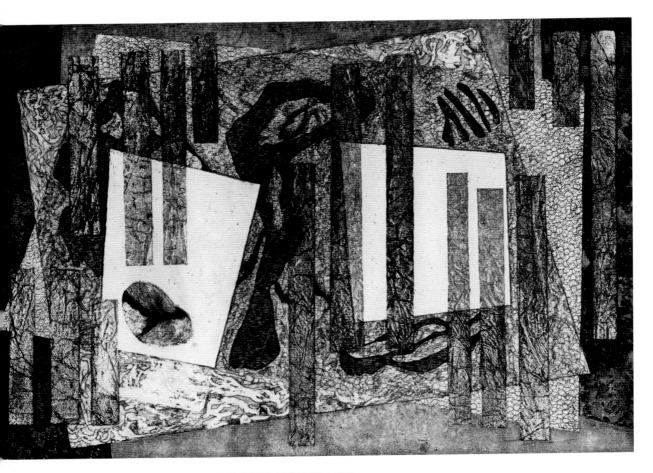

PLATE X INDICATIVE DISPLACEMENT 1947

9/25 10.375 x 15.625 inches

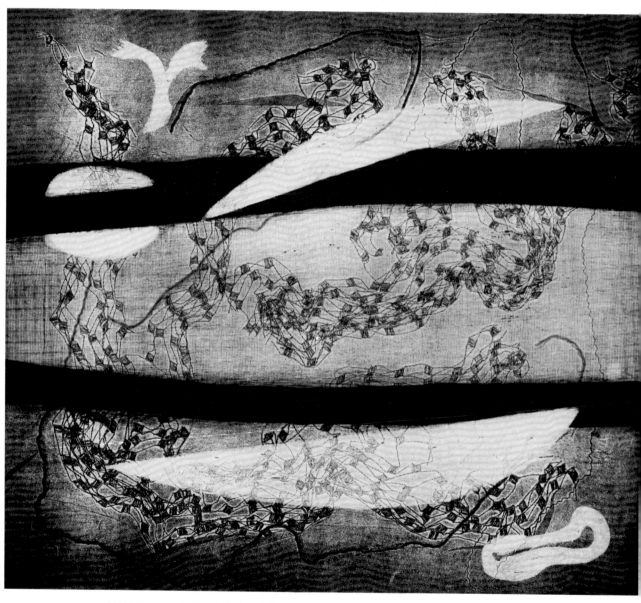

PLATE XI DEEP SOUND 1947

6/25 13.875 x 15.875 inches

24

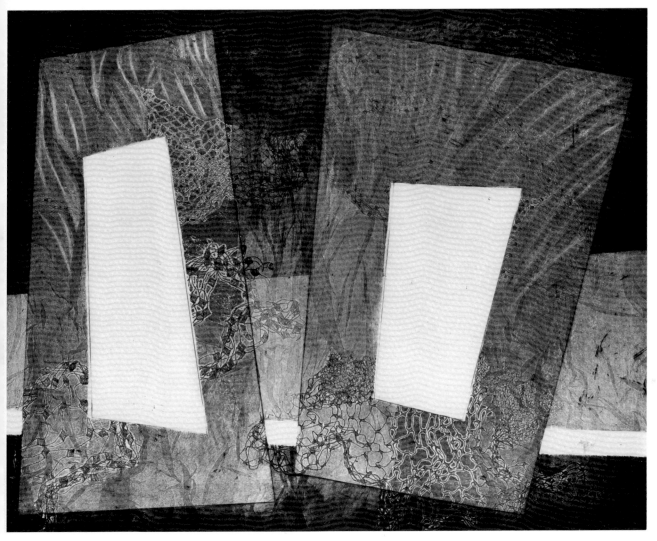

PLATE XII MARCH TIME 1950

8/25 13.875 x 17.5 inches

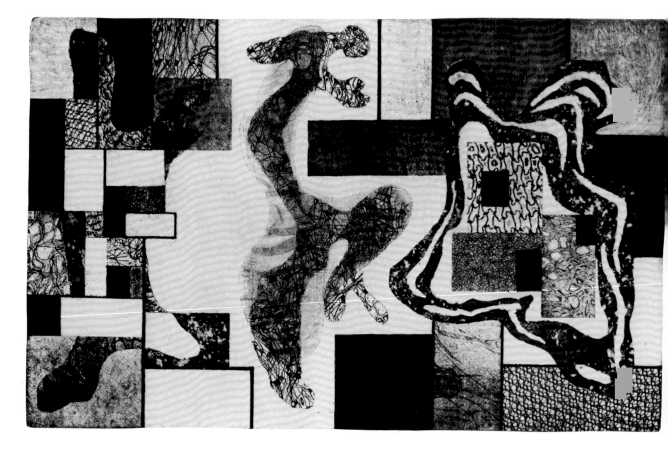

PLATE XIII THREE ELEMENTS 1950

1/25 9.75 x 15.75 inches

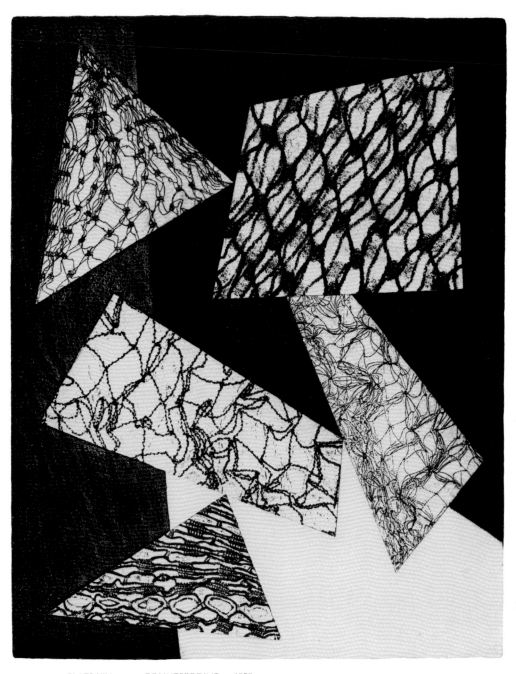

PLATE XIV COUNTERPOINT 1950

3/25 9.75 x 7.75 inches

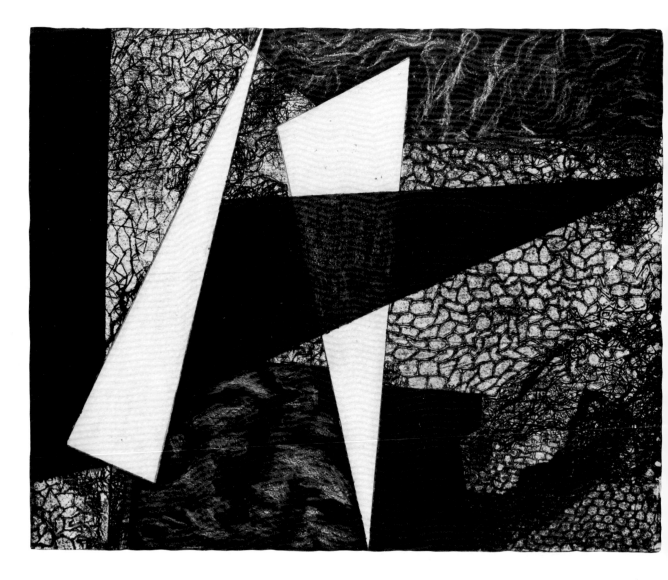

PLATE XV SWAN LAKE 1950

21/25 7.875 x 9.875 inches

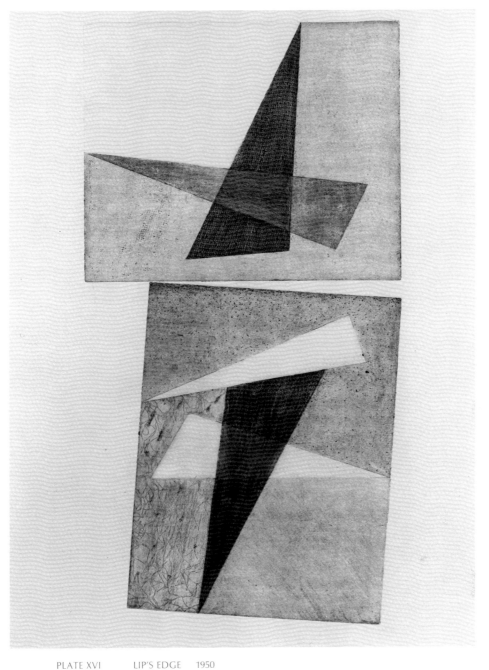

PLATE XVI LIP'S EDGE 1950

5/25 25 x 19.875 inches

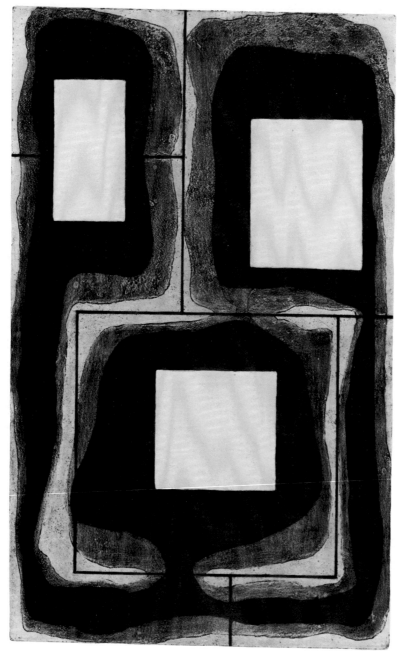

PLATE XVII DACTYL 1952

2/25 15.75 x 9.875 inches

30

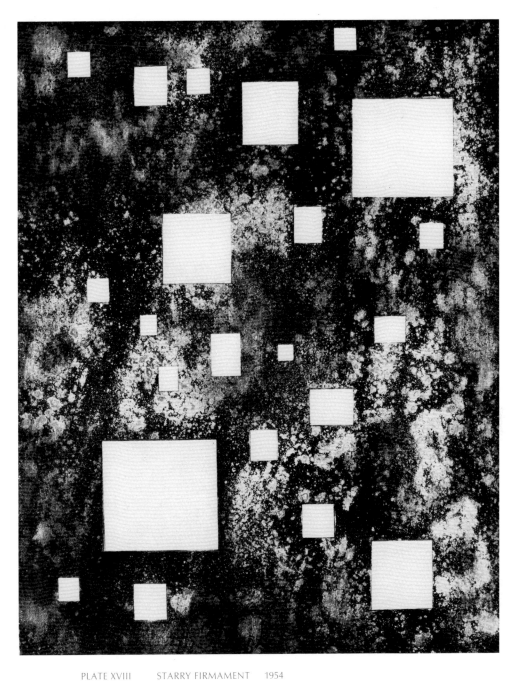

PLATE XVIII STARRY FIRMAMENT 1954

6/25 13.75 x 10.75 inches

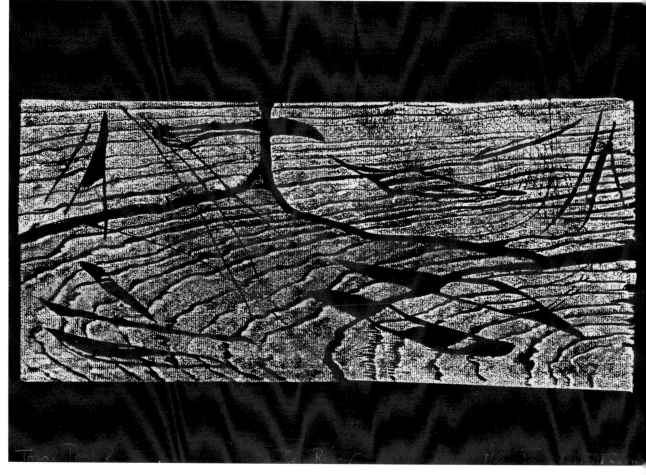

PLATE XIX ZEN RIVER 1960

trial proof 7 x 15.125 inches

32

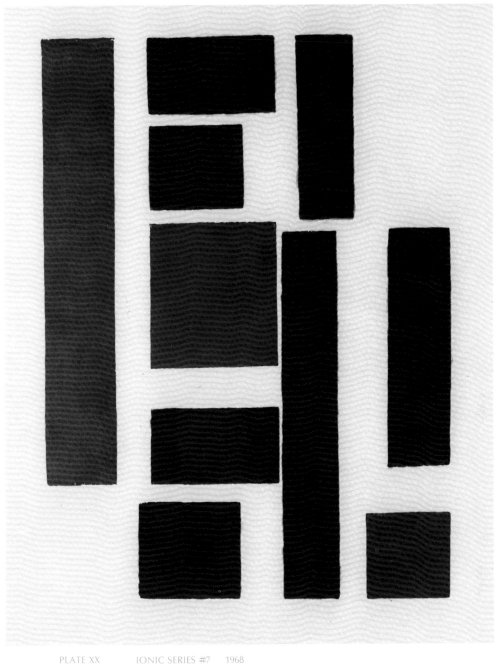

PLATE XX IONIC SERIES #7 1968

25 x 19.5 inches

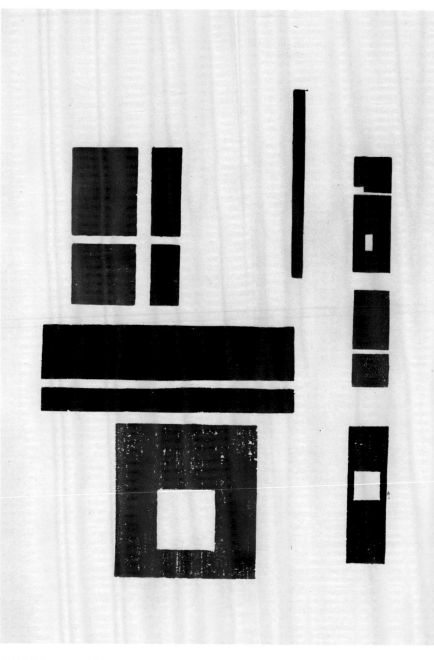

PLATE XXI SERIES WITH A BEAT 1969

25 x 18.625 inches

34

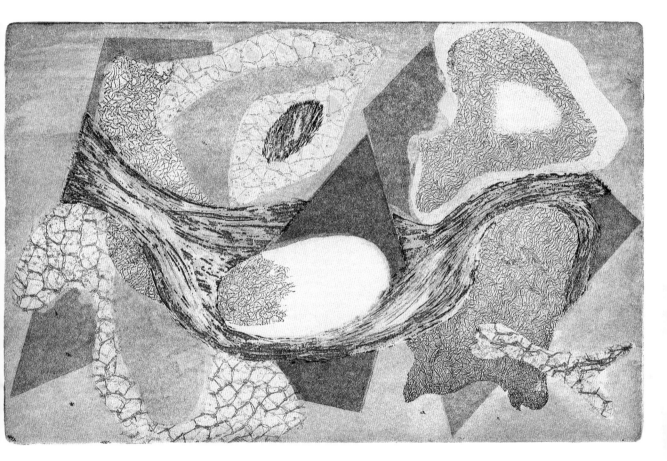

PLATE XXII SURFACE TENSION 1946

3/30 5 x 7.75 inches

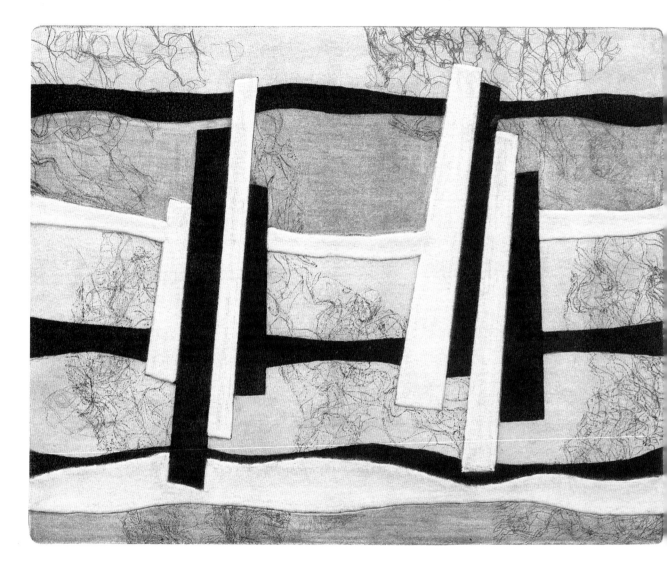

PLATE XXIII INVERSE 1949

5/20 7.75 x 9.875 inches

36

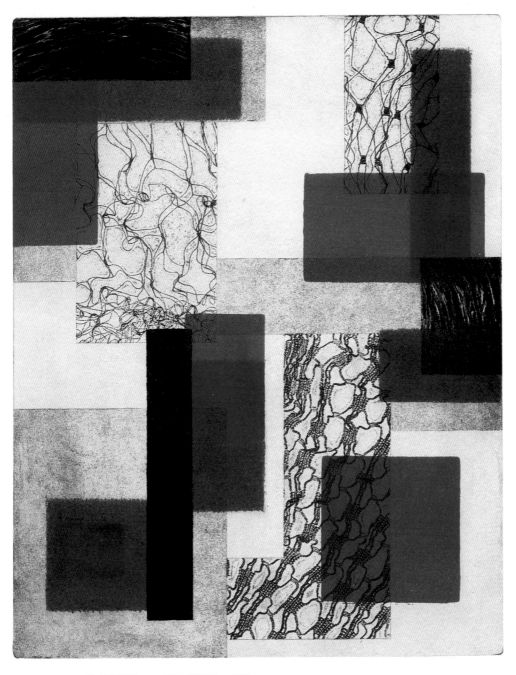

PLATE XXIV TRANSITIVE 1950

5/20 9.875 x 7.875 inches

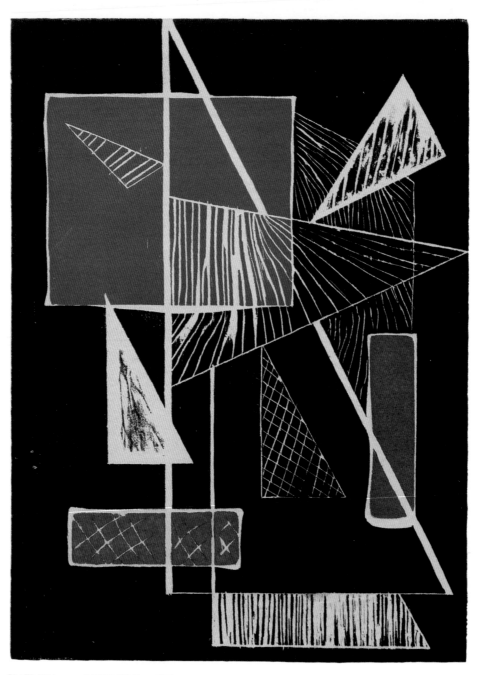

PLATE XXV 9 TRIANGLES 1952
 7/20 13 x 9.625 inches

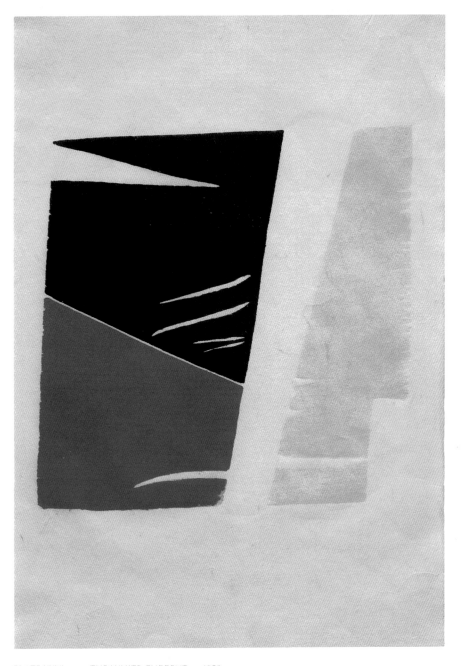

PLATE XXVI THE WHITE CURRENT 1952

11/20 12.375 x 8 inches

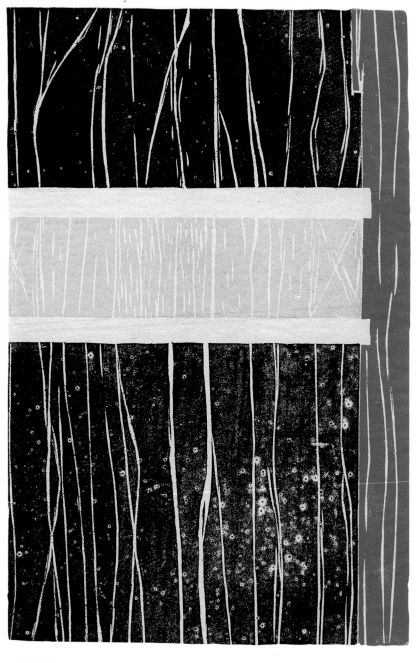

PLATE XXVII KITTY HAWK 1953
5/12 16 x 10.5 inches

40

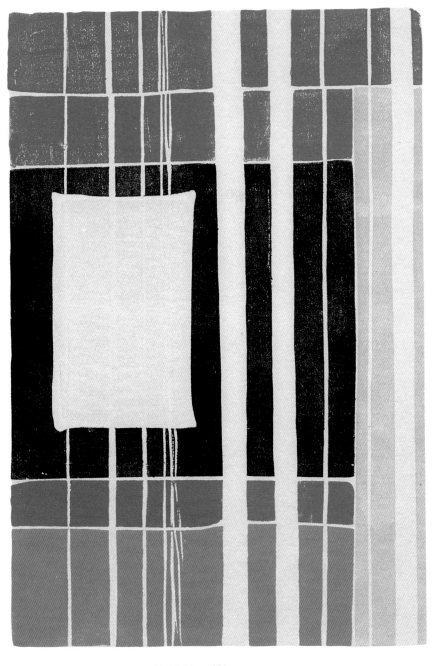

PLATE XXVIII TIDAL DEPTHS SEKISHU 1954
6/30 17 x 11 inches

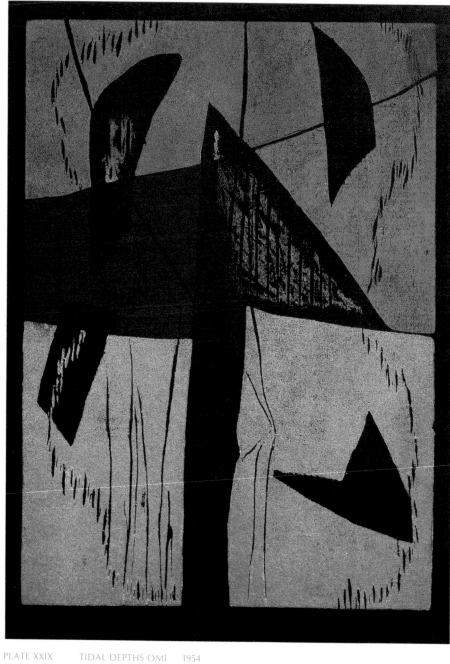

PLATE XXIX TIDAL DEPTHS OMI 1954

1/30 13 x 9.375 inches

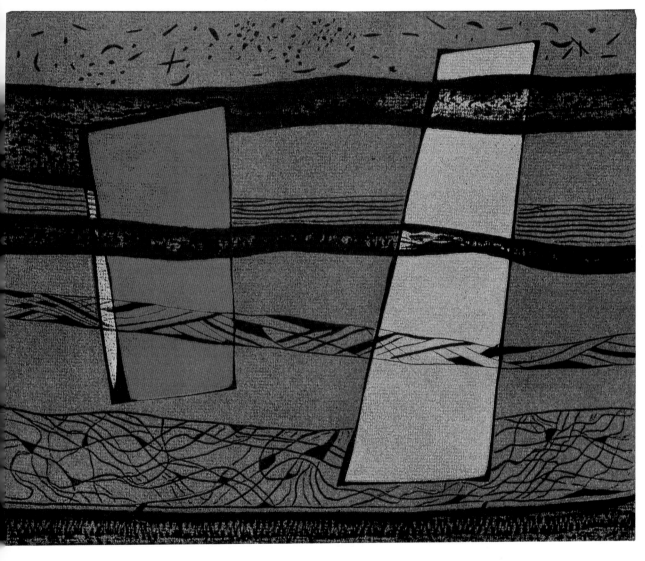

PLATE XXX LEEWAY 1955

20/20 8 x 10 inches

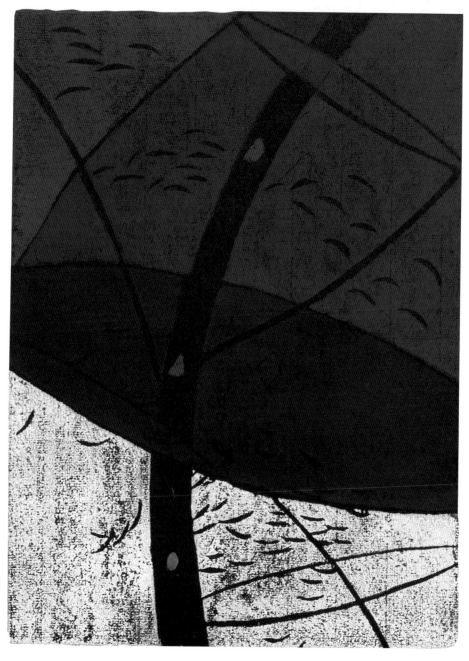

PLATE XXXI WIND AND WATER 1959

5/20 13 x 9.625 inches

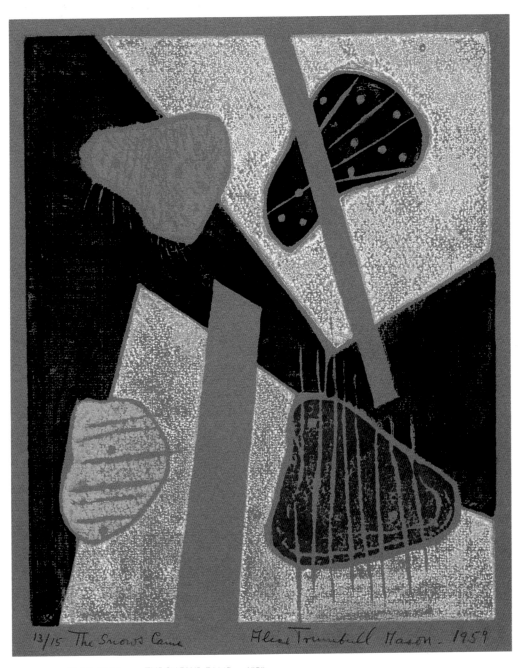

13/15 The Snows Came Alice Trumbull Mason. 1959

PLATE XXXII THE SNOWS CAME 1959

13/15 20 x 13 inches

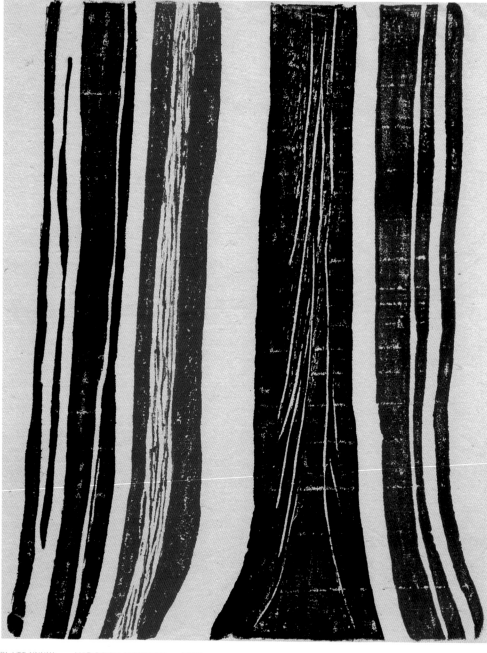

PLATE XXXIII WOODEN GROWTH 1962

3/25 12.5 x 9.75 inches

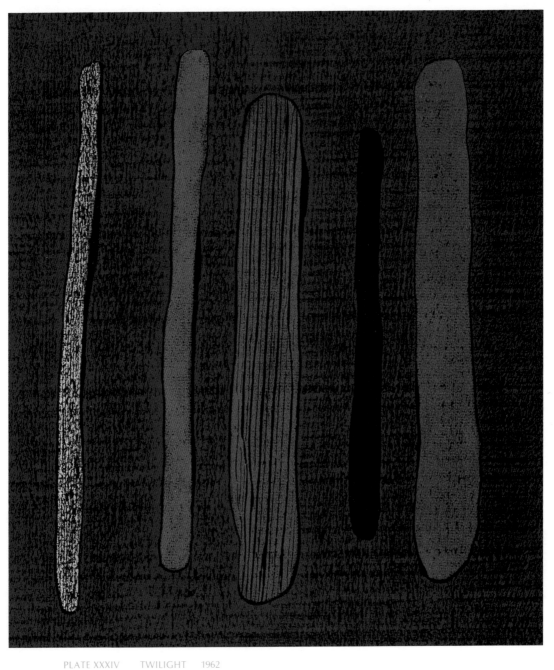

PLATE XXXIV TWILIGHT 1962

13/25 11.5 x 10.125 inches

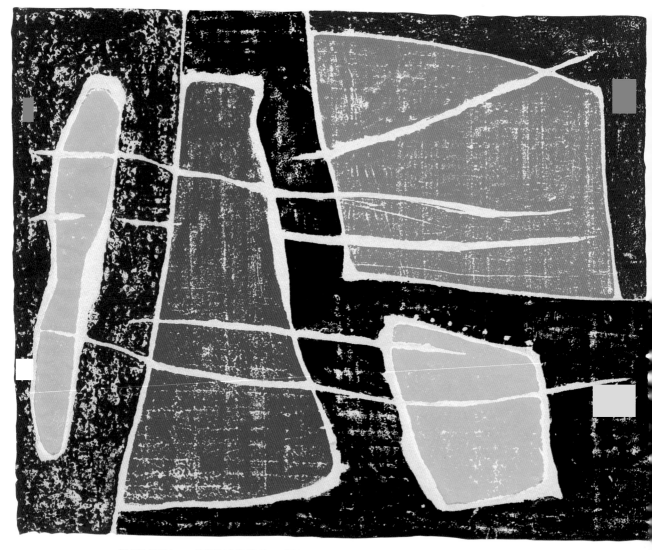

PLATE XXXV SUNDAY DAWN 1962

4/10 10 x 12.5 inches

ALICE TRUMBULL MASON

ETCHINGS AND WOODCUTS

PLATES

PLATE I INTERFERENCE OF CLOSED FORMS 1945
 8/20 11.25 x 13 inches
 Etching—soft ground and aquatint with deep bite

PLATE II AQUA BLACK 1945
 1/10 8.5 x 10.375 inches
 Etching—soft ground and aquatint

PLATE III PASSAGE TENSION 1945
 s/p 12.25 x 14.5 inches
 Etching—soft ground and aquatint
 Print before completion
 Paper gift of A. Rattner

PLATE IV ORIENTATION OF CLOSED FORMS 1945
 13/20 15.75 x 9.75 inches
 Etching—soft ground with deep bite

PLATE V SUSPENSION 1946
 9/30 9.875 x 14.625 inches
 Etching—soft ground with red and yellow stencil

PLATE VI WHITE SCAFFOLDING 1946
 8/30 13.5 x 9.625 inches
 Etching—soft ground

PLATE XV SWAN LAKE 1950
 21/25 7.875 x 9.875 inches
 Etching—soft ground and aquatint

PLATE XVI LIP'S EDGE 1950
 5/25 25 x 19.875 inches
 Etching—soft ground

PLATE XVII DACTYL 1952
 2/25 15.75 x 9.875 inches
 Etching—aquatint and burnished aquatint

PLATE XVIII STARRY FIRMAMENT 1954
 6/25 13.75 x 10.75 inches
 Etching—aquatint printed in either black or monastral blue-black

PLATE XIX ZEN RIVER 1960
 trial proof 7 x 15.125 inches
 Woodcut—white ink on black fabriano paper

PLATE XX IONIC SERIES #7 1968
 25 x 19.5 inches
 Woodblock—red and black on rice paper

PLATE XXI SERIES WITH A BEAT 1969
 25 x 18.625 inches
 Woodblock—red and black on rice paper

COLOR
PLATES

PLATE XXII SURFACE TENSION 1946
3/30 5 x 7.75 inches
Etching—soft ground and aquatint
Four plates: red, yellow, blue, and black

PLATE XXIII INVERSE 1949
5/20 7.75 x 9.875 inches
Etching—soft ground and aquatint / Two plates: red and black

PLATE XXIV TRANSITIVE 1950
5/20 9.875 x 7.875 inches
Etching—soft ground and aquatint with red and magenta surface stencil

PLATE XXV 9 TRIANGLES 1952
7/20 13 x 9.625 inches
Woodcut—red and black on rice paper

PLATE XXVI THE WHITE CURRENT 1952
11/20 12.375 x 8 inches
Woodblock—yellow, gray, and black on rice paper

PLATE XXVII KITTY HAWK 1953
5/12 16 x 10.5 inches
Woodcut—yellow, green, and black on rice paper

PLATE XXVIII TIDAL DEPTHS SEKISHU 1954
　　　　　　6/30 17 x 11 inches
　　　　　　Woodblock—blue, orange, flesh, naples-yellow, gray, and black on
　　　　　　　sekishu paper

PLATE XXIX TIDAL DEPTHS OMI 1954
　　　　　　1/30 13 x 9.375 inches
　　　　　　Woodcut—red, yellow, white on red-brown omi paper

PLATE XXX LEEWAY 1955
　　　　　　20/20 8 x 10 inches
　　　　　　Woodcut—yellow, orange, and white on black fabriano paper

PLATE XXXI WIND AND WATER 1959
　　　　　　5/20 13 x 9.625 inches
　　　　　　Woodcut—red, blue, brown and white on black fabriano paper

PLATE XXXII THE SNOWS CAME 1959
　　　　　　13/15 20 x 13 inches
　　　　　　Woodcut—dark green, light green, gray blue, white and black
　　　　　　　on brown fabiano paper

PLATE XXXIII WOODEN GROWTH 1962
　　　　　　3/25 12.5 x 9.75 inches
　　　　　　Woodcut—red-brown, blue, and black on rice paper

PLATE XXXIV TWILIGHT 1962
　　　　　　13/25 11.5 x 10.125 inches
　　　　　　Woodblock—white, pink, blue, and gray on black fabriano paper

PLATE XXXV SUNDAY DAWN 1962
　　　　　　4/10 10 x 12.5 inches
　　　　　　Woodcut—dark red, light red, yellow, pink, blue and black on rice paper

ALICE TRUMBULL MASON
1904–1971

EXHIBITIONS
PUBLIC COLLECTIONS
AWARDS

ONE-PERSON EXHIBITIONS

1942 The Museum of Living Art, New York University, New York

1948 The Rose Fried Gallery, New York

1951–52 Solo traveling show of prints, U.S.A.

1952 Coloured Woodcuts, Wittenbourn & Co., New York

1959 Hansa Gallery, New York

1967 The Fire House Gallery, Nassau Community College, New York

1969 The 20th Century Gallery, New York

1973 The Whitney Museum of American Art, New York
University of Nebraska Art Galleries, Lincoln, Nebraska
A. B. Closson Gallery, Cincinnati, Ohio

1974 Washburn Gallery, New York
Montgomery Museum of Art, University of Georgia, Athens, Georgia

1977 Washburn Gallery, New York

1979 Washburn Gallery, New York

1981 Washburn Galleries, New York

1982 Art Department Gallery, Newcomb College,
 Tulane University, New Orleans, Louisiana
Washburn Gallery, New York
Skidmore College Art Gallery, Saratoga Springs, New York

GROUP EXHIBITIONS

1937 American Abstract Artists, Squibb Galleries, New York

1938 American Abstract Artists, Municipal Art Galleries, New York

1939 American Abstract Artists, Riverside Museum, New York

1946 Museum of Living Art, New York University, New York

1973 "Post-Mondrian Abstraction in America,"
 Museum of Contemporary Art, Chicago, Illinois

1975 "Three American Purists: Mason, Miles, Von Wiegand,"
 Museum of Fine Arts, Springfield, Massachusetts
 "Selection I," Washburn Gallery, New York

1976 "Women Artists: 1550–1950," Los Angeles County Museum, California,
 and Brooklyn Museum, New York
 "American Abstract Painting from the 1930s and 1940s,"
 Washburn Gallery, New York

1978 "Sculpture and Works on Paper from the 1930s and 1940s,"
 Washburn Gallery, New York

1979 "Abstract Art in America from 1930 to 1940: Influence and Development,"
 Washburn Gallery, New York
 "American Paintings, Drawings, Watercolors & Sculpture, 1940–50,"
 Washburn Gallery, New York

1980 "Pioneering Women Artists, 1900–1940," Helen Serger,
 La Boetie, Inc., New York
 "Circa 1910–1950," Washburn Gallery, New York
 "Time and Space," Washburn Gallery, New York

1981 "American Artists in the A. E. Gallatin Collection,"
 Washburn Gallery, New York
 "Gilbert Rhode, American Furniture Designer," Washburn Gallery, New York

1982 "Miro in America," Museum of Fine Arts, Houston, Texas

1983 "A Family in Art—Mason, Kahn, Mason," Kornbluth Gallery, New Jersey
 "Under Glass," Washburn Gallery, New York
 "Mothers and Daughters," Gross McCleaf Gallery, Philadelphia, Pennsylvania
 "Abstract Painting and Sculpture in America 1927–1944," Museum of Art,
 Carnegie Institute, Pittsburgh, Pennsylvania (traveling exhibition)

1984 "American Abstract Painting from the 1930s and 1940s,"
 Washburn Gallery, New York
 "Mothers and Daughters," Blair Art Extension,
 Hollidaysburn, Pennsylvania

The Berkshire Museum of Art, Lenox, Massachusetts

Boston Public Library, Boston, Massachusetts

The Brooklyn Museum of Art, Brooklyn, New York

Hirshhorn Museum and Sculpture Garden, Washington, D.C.

Lehman Brothers, Kuhn and Loeb, Inc., New York

The Library of Congress, Washington, D.C.

The Metropolitan Museum of Art, New York

The Museum of Modern Art, New York

McCrory Corporation, New York

The New York Public Library, New York

The Philadelphia Museum of Art, Philadelphia, Pennsylvania

Phoenix Art Museum, Phoenix, Arizona

The Solomon R. Guggeheim Museum, New York

The Springfield Museum, Springfield, Massachusetts

The Union Carbide Collection, New York

University of Nebraska Art Gallery, Lincoln, Nebraska

Whitney Museum of American Art, New York

AWARDS

1946 Charles M. Lea Prize, The Print Club, Philadelphia, Pennsylvania

1948 Treasurer's Prize, The Society of American Graphic Artists

1963 The Longview Foundation, painting purchased and placed in
 The Walker Art Center, Minneapolis, Minnesota

BIBLIOGRAPHY

ALICE IN MONDRIANLAND
Grace Glueck, *New York Times*, June 3, 1973

ART: ALICE MASON ABSTRACTS
Hilton Kramer, *New York Times*, May 19, 1973
Black and white photograph: *The Necessity of Yellow*, 1945

ALICE TRUMBULL MASON
B. Thomas Hess, *New York Magazine*, June 4, 1973

ALICE TRUMBULL MASON
Peter Frank, *Art News*, September 1973, Page 86

RECOGNITION TO ARTIST AFTER DEATH
Joseph Kaye, *The Kansas City Star*, May 30, 1973
Black and white photograph: portrait

MASSACHUSETTS WORKS SHOWN IN NYC GALLERIES
Lee Sheridan, *Daily News*, Springfield, Massachusetts, May 3, 1974

ALICE TRUMBULL MASON
Judith Tannenbaum, *Arts*, September 1974, Page 64

THREE AMERICAN PURISTS: MASON, MILES, VON WIEGAND
Joseph Butler, *Connoisseur*, July 1975, Page 237

REDISCOVERED—WOMEN PAINTERS
Robert Hughes, *Time*, January 10, 1977, Page 60
Color photograph: *L'Hasard*, 1948

AT LAST A SMALL HOME FOR AMERICAN ART
John Russell, *New York Times*, February 13, 1977

RE-PLACING WOMEN ARTISTS IN HISTORY
Jan Butterfield, *Art News*, March 1977, Pages 40–44
Black and white photograph: *L'Hasard*, 1948

ALICE TRUMBULL MASON
Vivian Raynor, *New York Times*, October 21, 1977

ALICE T. MASON
Ellen Schwartz, *Art News*, December 1977, Page 133

ALICE TRUMBULL MASON
Hilton Kramer, *New York Times*, November 16, 1979

ALICE TRUMBULL MASON
Grace Susan Galassi, *Arts*, January 1980, Page 31
Black and white photograph: *The Yellow Ochre Ground*, 1943

ALICE TRUMBULL MASON
Hilton Kramer, *New York Times*, January 30, 1981

ALICE TRUMBULL MASON
Addison Parks, *Arts*, February 1981, Page 34
Black and white photograph: *Beside the Way*, Fall 1930

ALICE TRUMBULL MASON, EMILY MASON:
TWO GENERATIONS OF ABSTRACT PAINTING
Marilyn Brown, monograph to accompany exhibition of the same title, 1982
Review of the ATM–EM exhibition by Grace Glueck, *New York Times*, June 25, 1982

TALKING ABOUT ART
Barbara Rose, *Vogue*, September 1982, Page 165
Colored photograph:*Magnetic Field*, 1951

ALICE TRUMBULL MASON/EMILY MASON
Barbara Gallati, *Arts*, October 1982, Page 23
Colored photograph: *Magnetic Field*, 1951

A FAMILY AFFAIR IN FAIR LAWN
Vivien Raynor, *New York Times*, February 13, 1983
Black and white photograph: *Magnetic Field*, 1951

AMERICAN WORKS OF THE 30'S IN STAMFORD
Wiliam Zimmer, *New York Times*, August 21, 1983
Black and white photograph: *Free White Spacing*, c. 1930s

A MOTHER-DAUGHTER EXHIBIT
Victoria Donohoe, *Philadelphia Inquirer*, December 31, 1983

Composed in Optima by American–Stratford Graphic Services; color separated and printed on Warren's 80 lb. Lustro Offset Enamel Dull by Eastern Press; and bound in Kingston Linen by A. Horowitz & Sons under the supervision of Orion Book Services, West Brattleboro, Vermont. Design by Marjorie Merena.